SEEING The Getty Villa

Principal Photography by Richard Ross

THE J. PAUL GETTY MUSEUM • LOS ANGELES

President's Message

In 1954, the original J. Paul Getty Museum opened in a large ranch house in Malibu. It was used by J. Paul Getty to exhibit his growing collection of Greek and Roman antiquities, Renaissance and Baroque paintings, and European decorative arts. By the mid-1960s the house could no longer accommodate his collections, so Mr. Getty commissioned a new building based on the Villa dei Papiri, a Roman country house in ancient Herculaneum that was buried by the eruption of Mount Vesuvius in A.D. 79. Construction on the Getty Villa began in 1971, and the Museum opened to the public in 1974. In 1997, the Villa closed for nine years of renovation. Now, the architecture and collections of the J. Paul Getty Museum at the Getty Villa allow visitors to be swept back in time to the ancient past.

The Getty Villa is a unique resource not only for Los Angeles but also for the world. As an educational center and museum dedicated to the study of the arts and cultures of the ancient Mediterranean, it serves a varied audience through exhibitions, conservation, scholarship, research, and public programs. Activities at the Villa involve all four programs of the J. Paul Getty Trust: the Getty Conservation Institute, the Getty Foundation, the Museum, and the Getty Research Institute. Conservation labs provide innovative avenues for research and teaching. Remodeled and expanded galleries showcase our antiquities collection, one of America's finest. The Outdoor Classical Theater each year hosts reimagined versions of classical drama, while in the auditorium there are presentations of a wide range of concerts, performances, and symposia.

The Villa's setting, collections, and programs are woven together to create an integrated institution that provides a wealth of experience for students, scholars, specialists, and general audiences. The Villa continues the mission of the Getty Trust and the vision of its founder: to delight, inspire, and educate through the collection, preservation, exhibition, and interpretation of works of art of the highest quality.

James N. Wood
President and Chief Executive Officer
The J. Paul Getty Trust

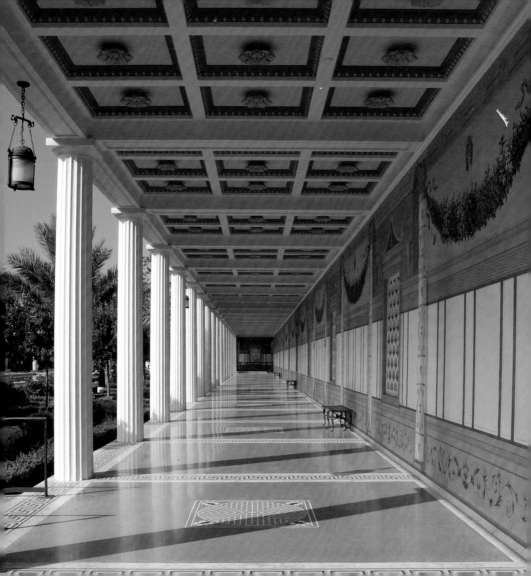

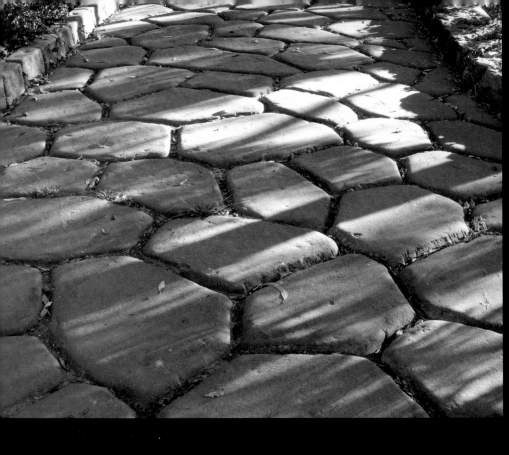

As visitors enter the grounds of the Getty Villa from the Pacific Coast, they are immediately transported back in time. A road of polygonal flagstones, modeled on those built by ancient engineers throughout the Roman Empire, leads to the façade of a luxurious private home. The J. Paul Getty Museum at the Getty Villa is a full-scale replica of the Villa dei Papiri, a Roman country house in Herculaneum destroyed by the eruption of Mt. Vesuvius in *a.d*. 79. Where colonnaded gardens and fountains once provided settings for the leisure of aristocrats in ancient times, today they offer pleasure to visitors to one of the world's premier collections of Greek, Etruscan, and Roman antiquities.

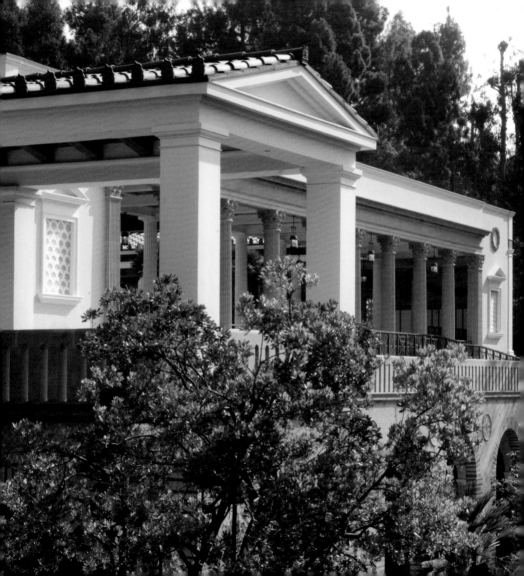

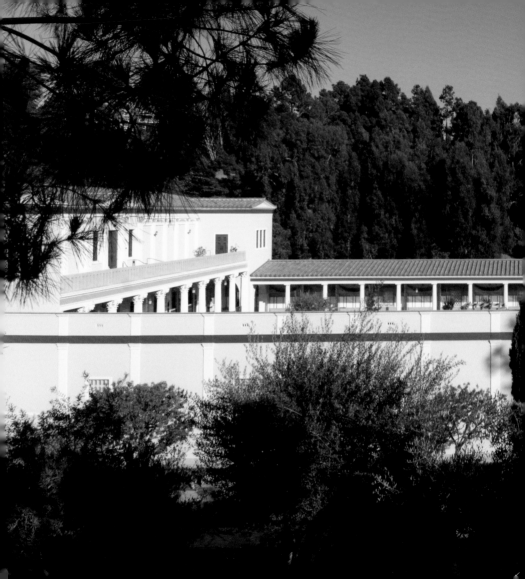

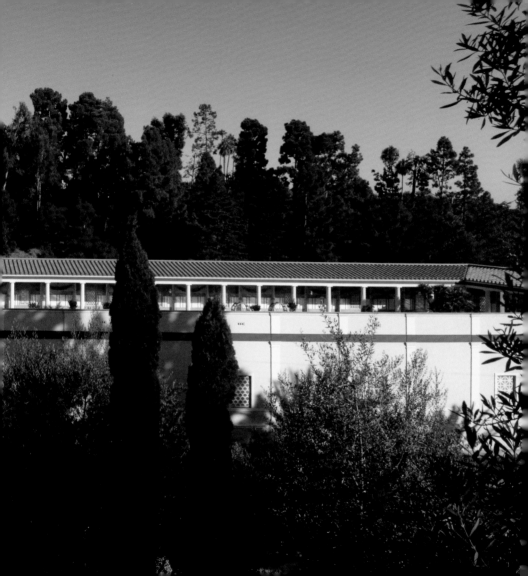

Access to the Villa complex is through the Entry Pavilion, a modern open-air structure, whose floors and walls of diverse materials, ranging from concrete to marble, recall the changing layers of archaeological sites.

The J. Paul Getty Museum at the Getty Villa is the principal part of a larger complex. It houses the permanent collection of classical antiquities as well as galleries dedicated to changing exhibitions. An outdoor Greek-style theater provides a setting for the production of concerts and ancient plays. Visitors can also dine both indoors and outdoors at the Museum Cafe and shop at the Museum Store.

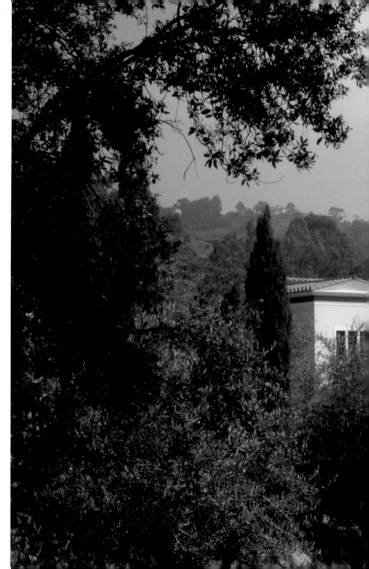

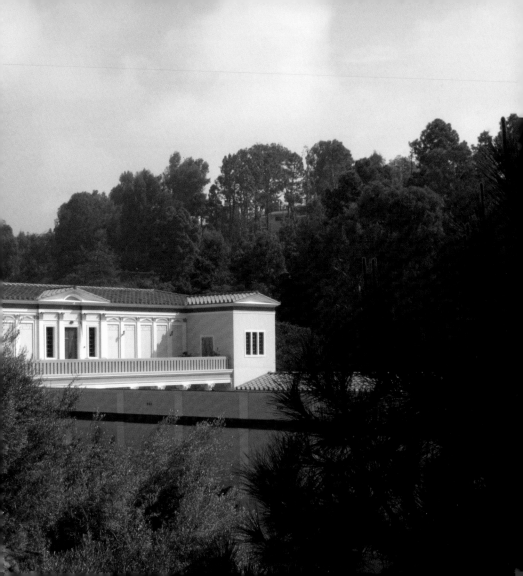

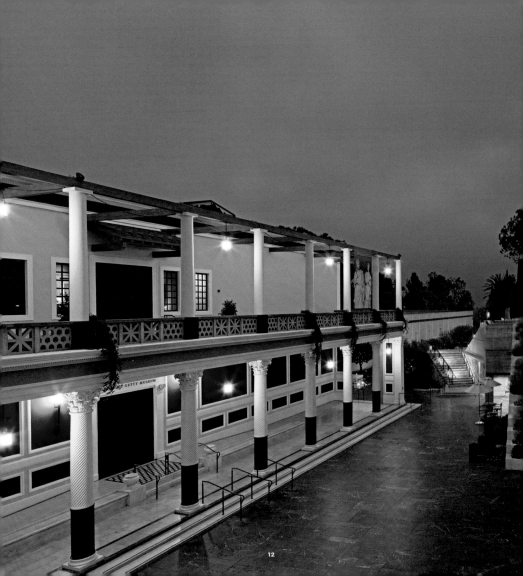

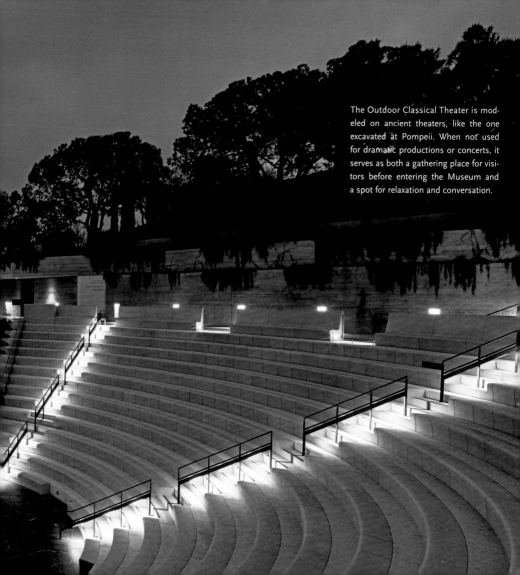

The Outdoor Classical Theater is modeled on ancient theaters, like the one excavated at Pompeii. When not used for dramatic productions or concerts, it serves as both a gathering place for visitors before entering the Museum and a spot for relaxation and conversation.

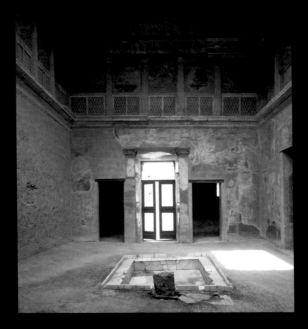

Although the Museum is modeled on the Villa dei Papiri, which has only been partially excavated, architectural details have been taken from a number of other ancient Roman buildings. The House of the Samnites at Herculaneum (above) provided the prototype for the Atrium of the Museum (right). The stone and mosaic floors are copied from the House of the Faun and House of Arius Diomedes at Pompeii, while the decorative frieze of florals and lions' heads (seen on page 16) surrounding the compluvium, or ceiling opening, are derived from the House of the Vettii at Pompeii and the Temple of Apollo at Metapontum.

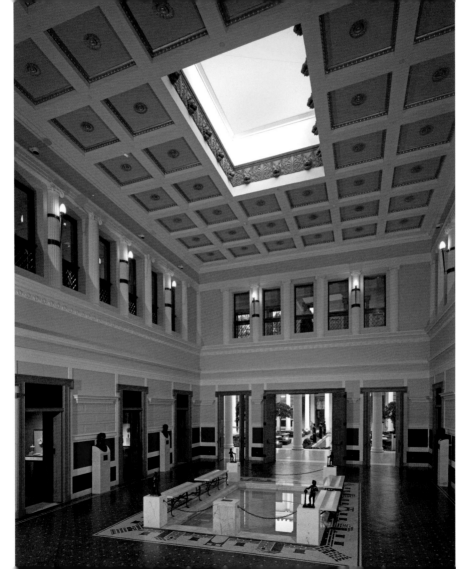

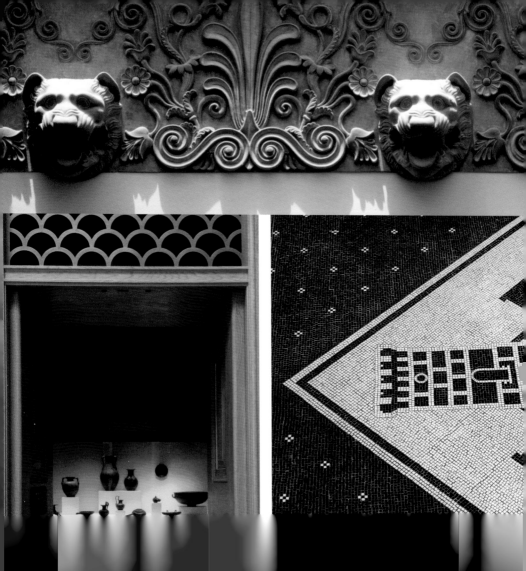

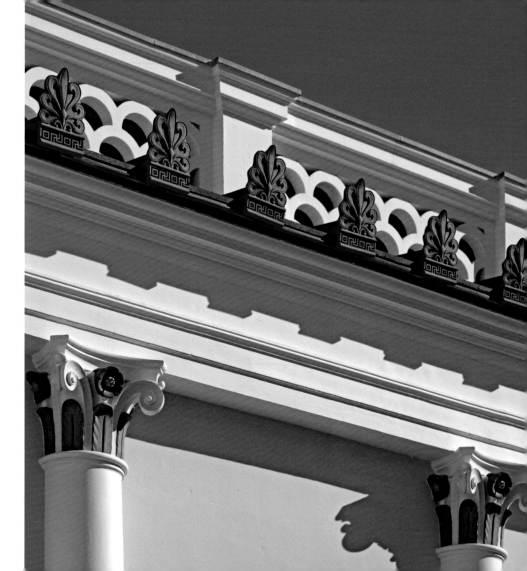

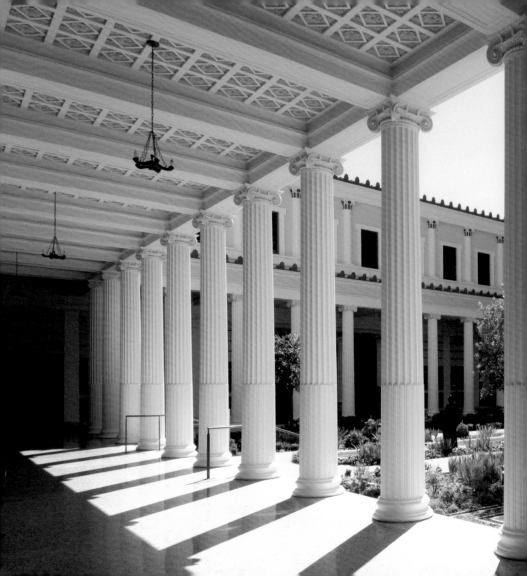

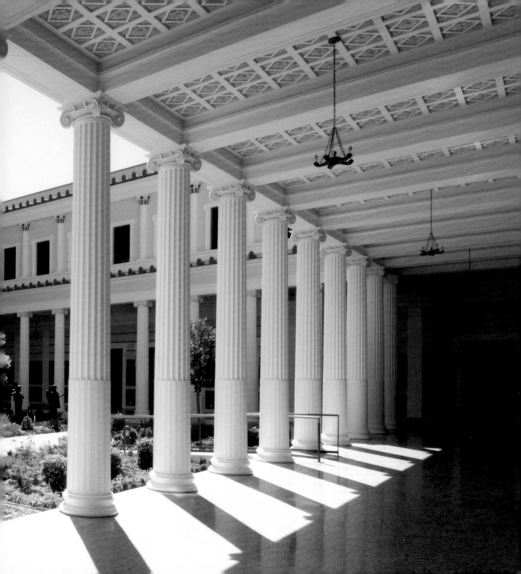

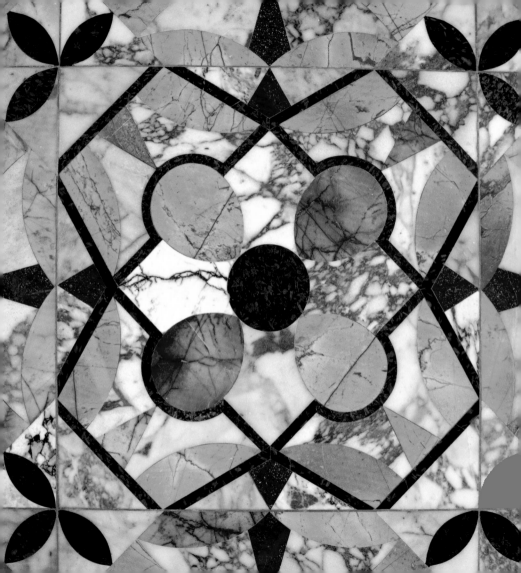

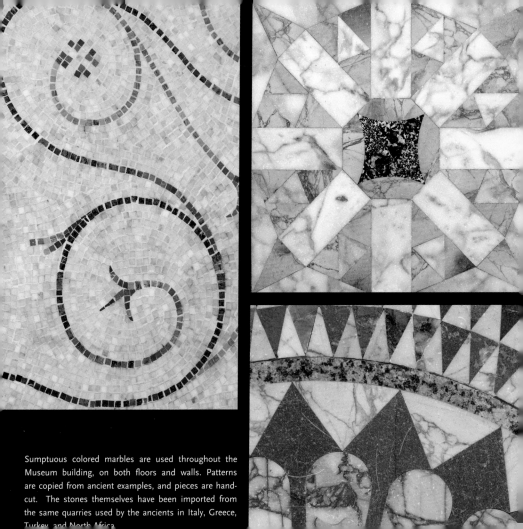

Sumptuous colored marbles are used throughout the Museum building, on both floors and walls. Patterns are copied from ancient examples, and pieces are hand-cut. The stones themselves have been imported from the same quarries used by the ancients in Italy, Greece, Turkey, and North Africa.

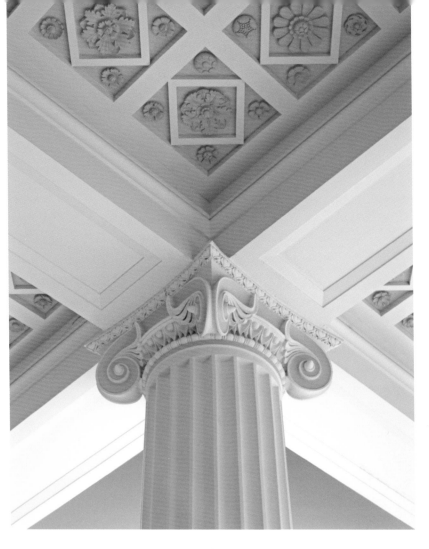

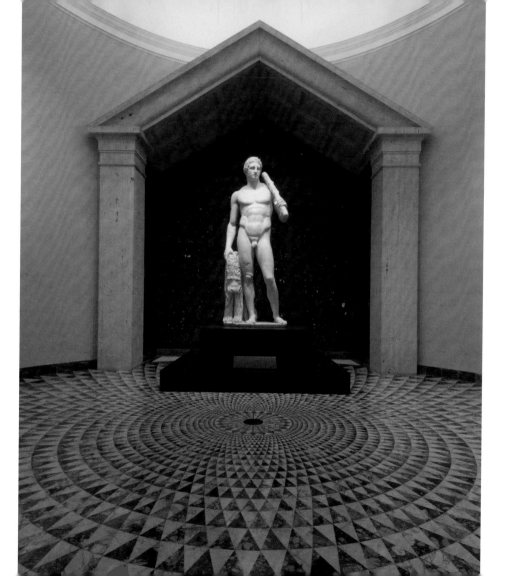

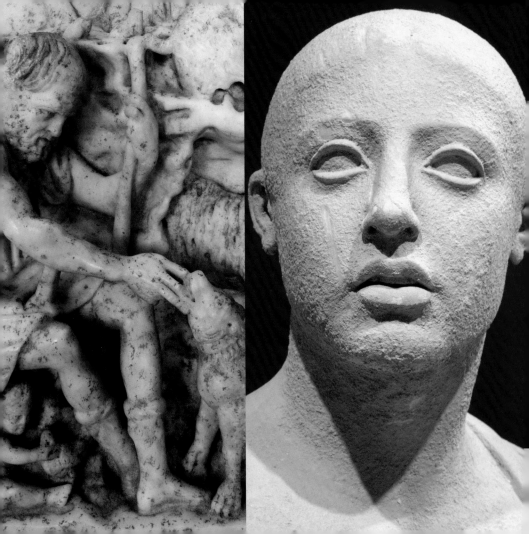

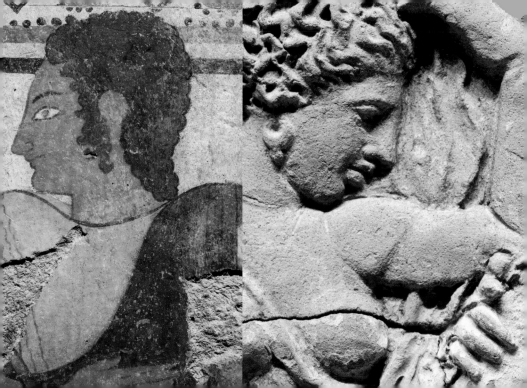

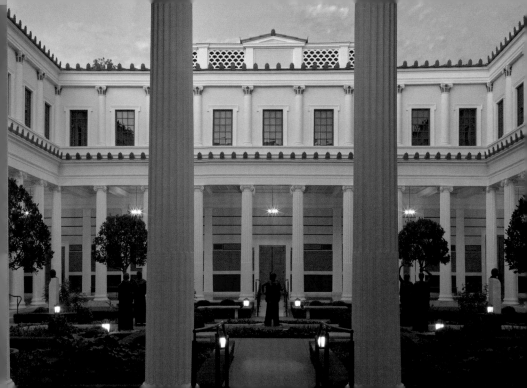

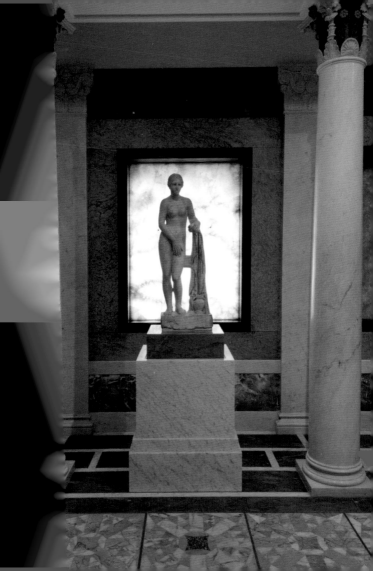

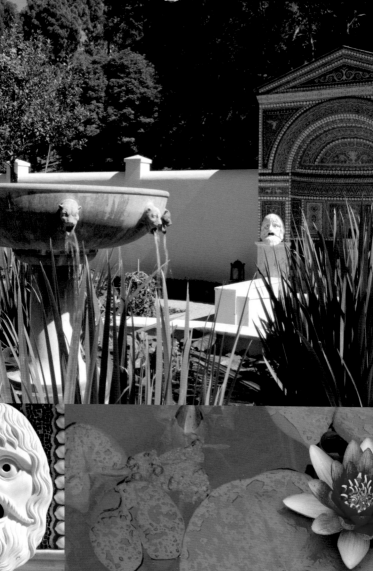

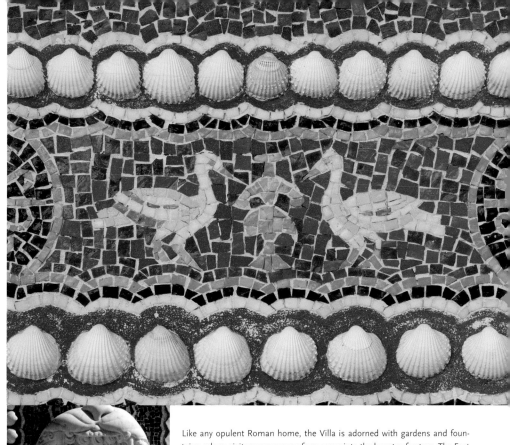

Like any opulent Roman home, the Villa is adorned with gardens and fountains, where visitors can escape from cares into the beauty of nature. The East Garden contains a replica of a fountain from Pompeii, decorated with mosaics of stone and glass tesserae as well as seashells. Directly opposite the Outdoor Classical Theater, it also features two theatrical masks in marble. These depict Herakles (the Roman Hercules) wearing his lionskin (at near left), and his cousin Dionysos, the patron god of theater.

29

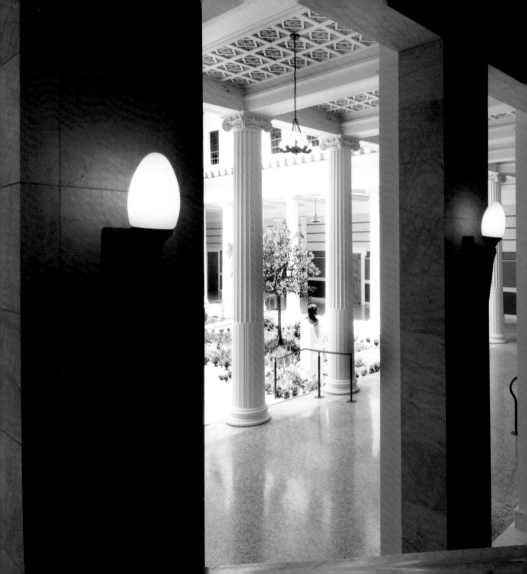

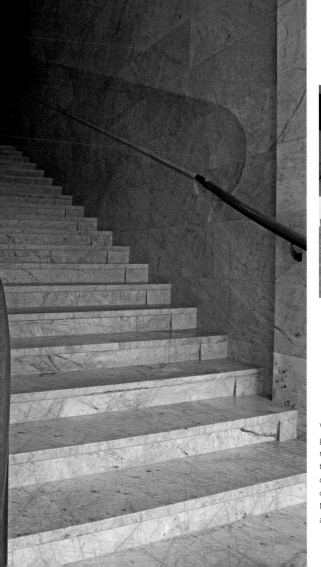

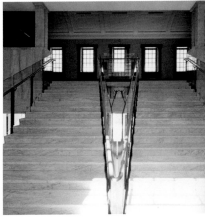

While ancient Roman houses did not have grand staircases, the Getty Villa's serves the needs of modern museum-goers. Thus architects Rodolfo Machado and Jorge Silvetti designed an elegant Beaux Arts staircase of yellow marble, bronze, and glass on the Museum's central axis to allow visitors access to the upper floor galleries.

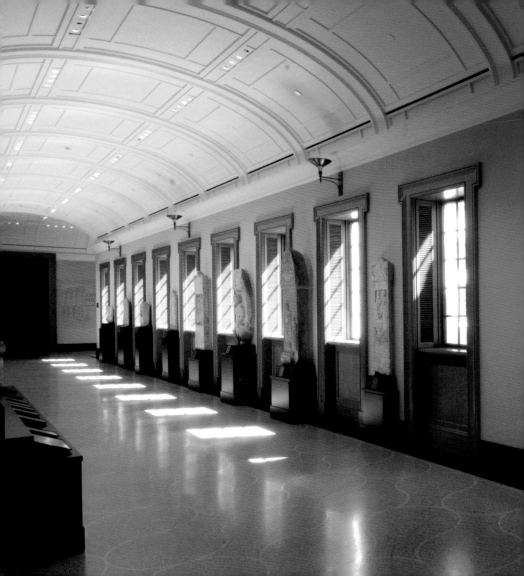

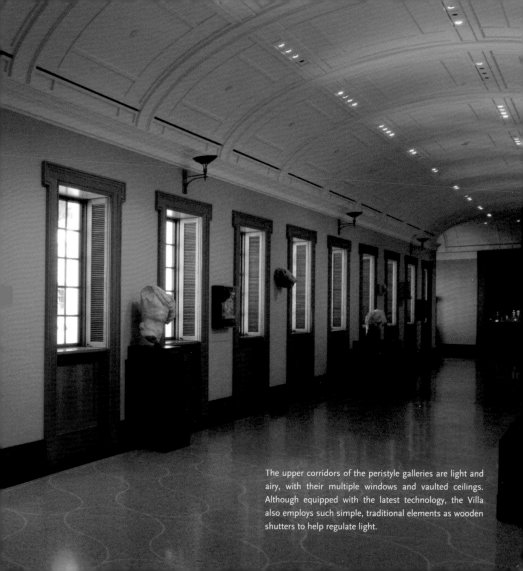

The upper corridors of the peristyle galleries are light and airy, with their multiple windows and vaulted ceilings. Although equipped with the latest technology, the Villa also employs such simple, traditional elements as wooden shutters to help regulate light.

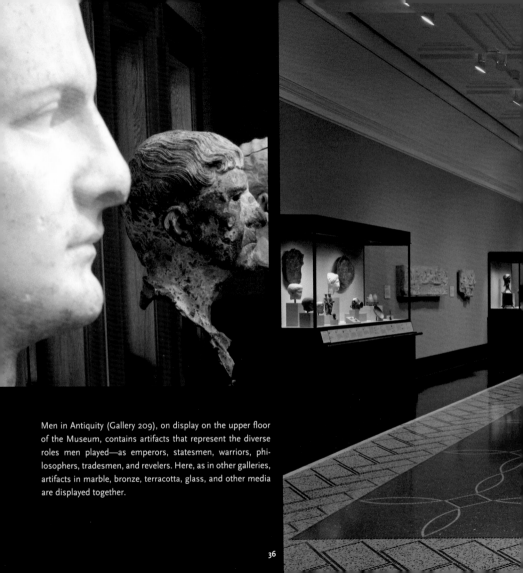

Men in Antiquity (Gallery 209), on display on the upper floor of the Museum, contains artifacts that represent the diverse roles men played—as emperors, statesmen, warriors, philosophers, tradesmen, and revelers. Here, as in other galleries, artifacts in marble, bronze, terracotta, glass, and other media are displayed together.

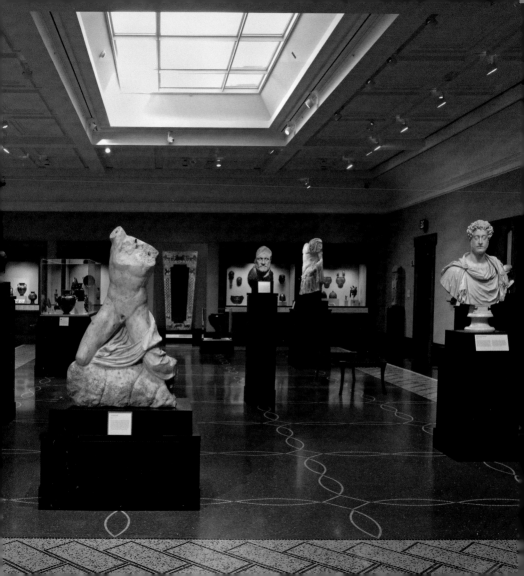

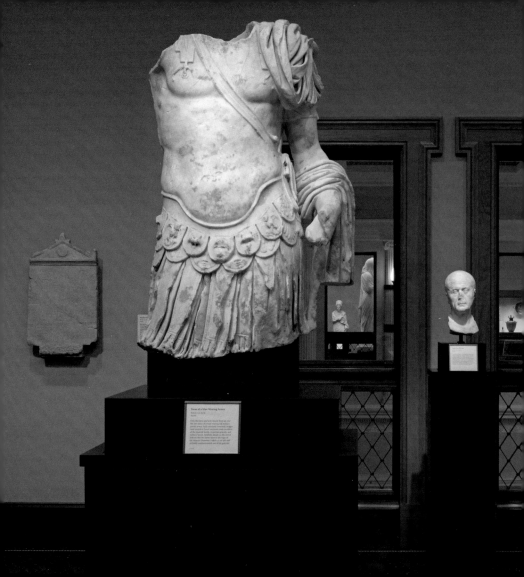

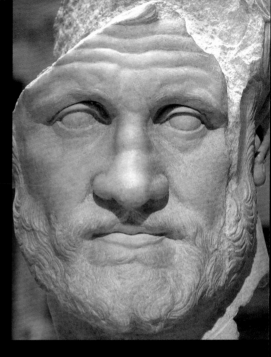

The Museum's collection of portraits is exceptional. Whether depicting emperors or philosophers, intended for public squares or tombs, these images not only bring viewers face to face with the inhabitants of the ancient world but also convey a sense of the values they held dear.

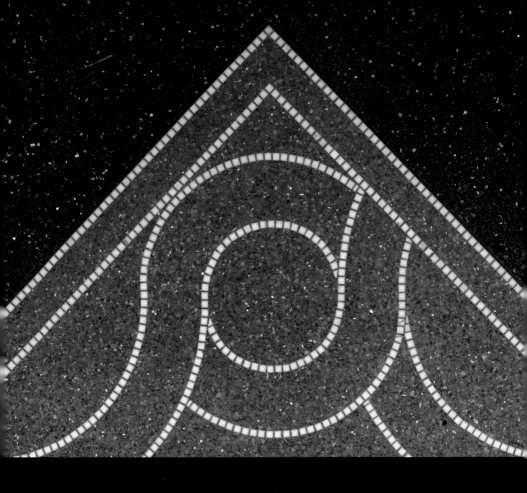

Some of the Museum's floors are made of mosaic or cut stone, but most are terrazzo, a composite of stone chips polished to a high sheen. The decorative patterns in each gallery, marked by Roman numerals in bronze and based on ancient models, are unique.

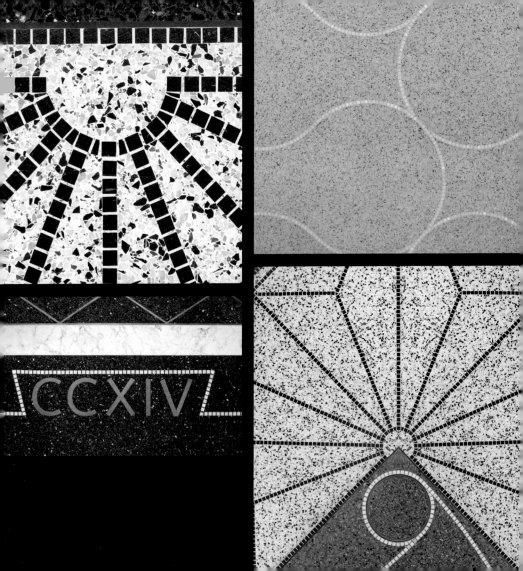

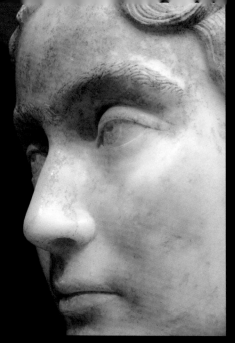

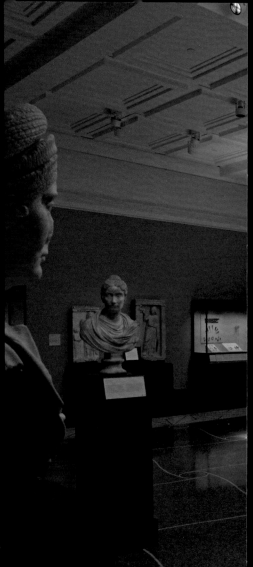

Portraits of important individuals dominate Women and Children in Antiquity (Gallery 207) on the second floor of the Villa. Marble sculpture is best appreciated in natural light, and windows and skylights throughout the Museum provide ever-changing views of ancient masterpieces. This gallery also contains exquisite gold jewelry, grave monuments, and numerous vessels fashioned from diverse materials.

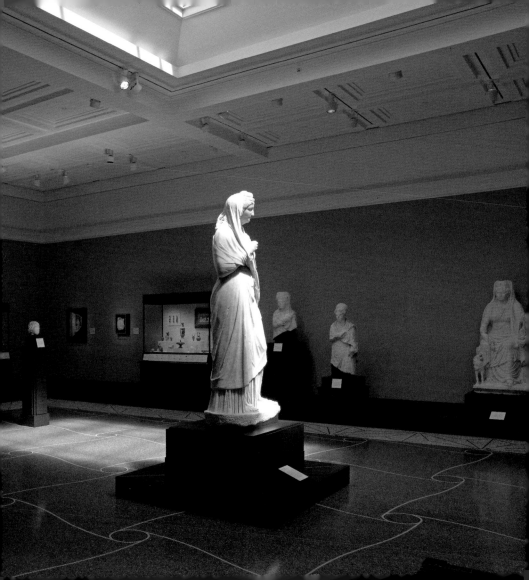

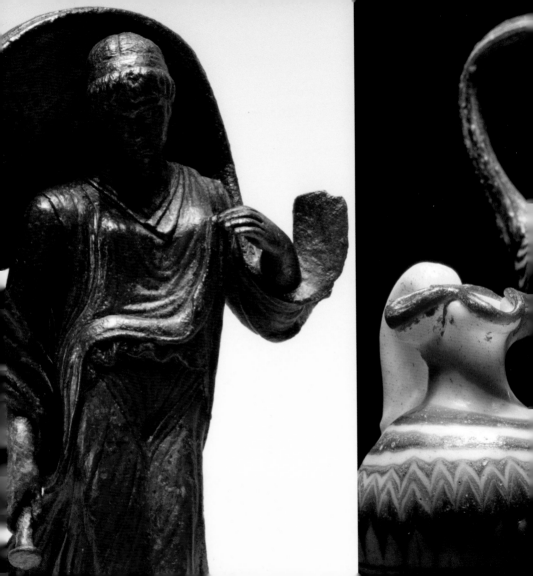

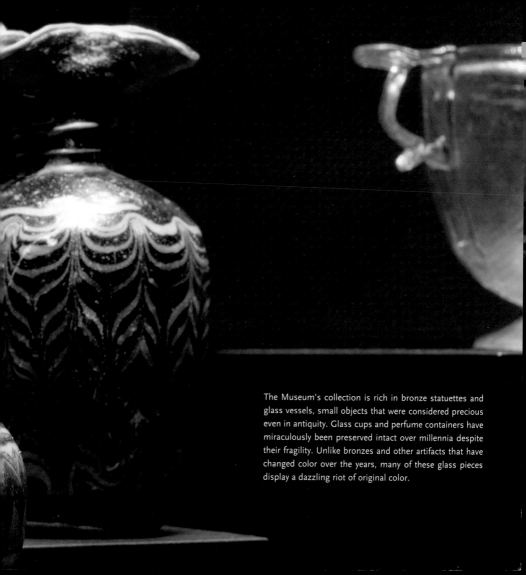

The Museum's collection is rich in bronze statuettes and glass vessels, small objects that were considered precious even in antiquity. Glass cups and perfume containers have miraculously been preserved intact over millennia despite their fragility. Unlike bronzes and other artifacts that have changed color over the years, many of these glass pieces display a dazzling riot of original color.

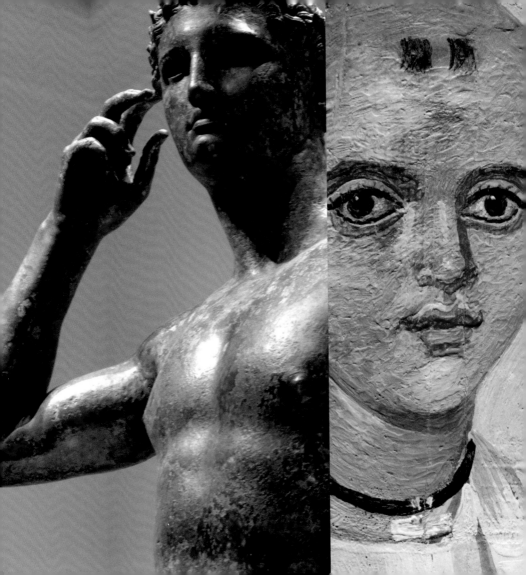

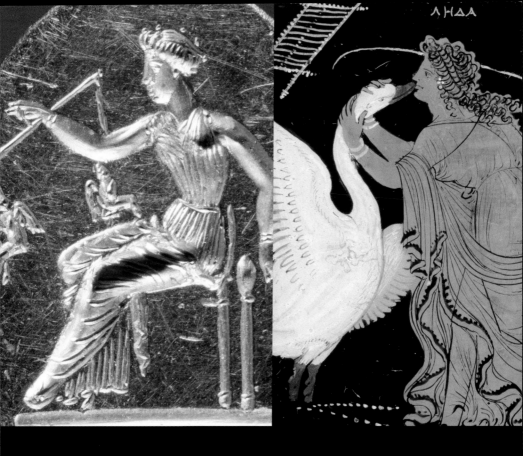

In addition to marbles, bronzes, and ceramics, the ancients also produced magnificent works of art in other materials, such as paintings on walls and panels, engraved gemstones, gold jewelry, and silver vessels. The Museum displays a wealth of these precious objects, which were highly valued by the ancients.

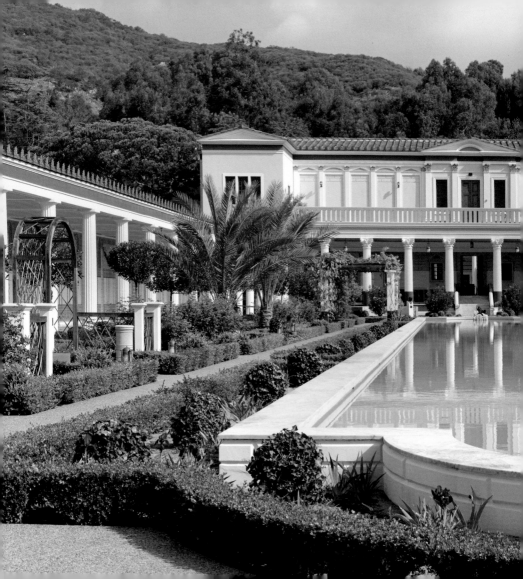

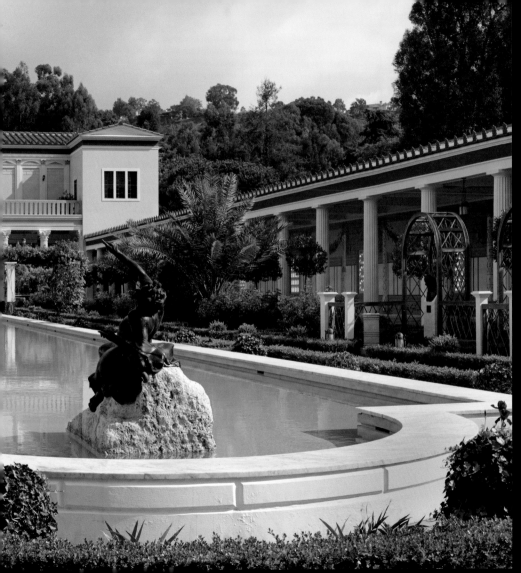

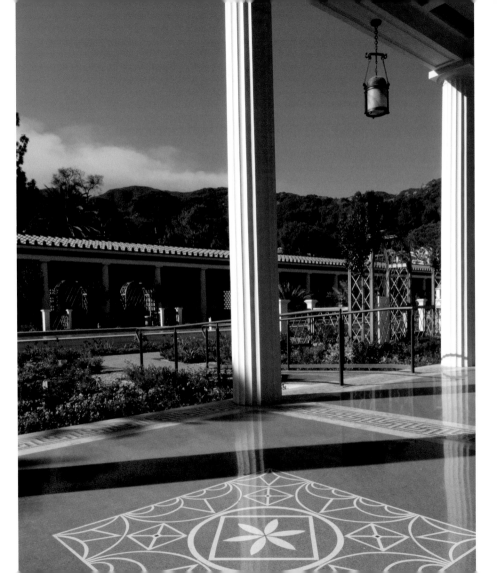

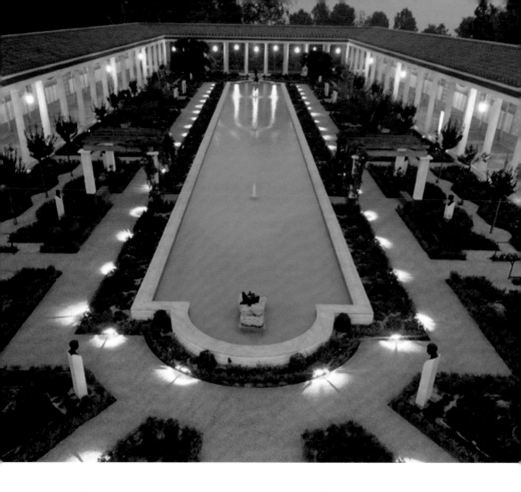

Visitors to the Outer Peristyle can—like their ancient predecessors—stroll along the shaded colonnades, enjoying the open air and ever-changing views of sky, plants, fountains, and statuary. They can also reflect on the ingenious trompe l'oeil wall-paintings, which are inspired by examples excavated in the homes of wealthy Romans.

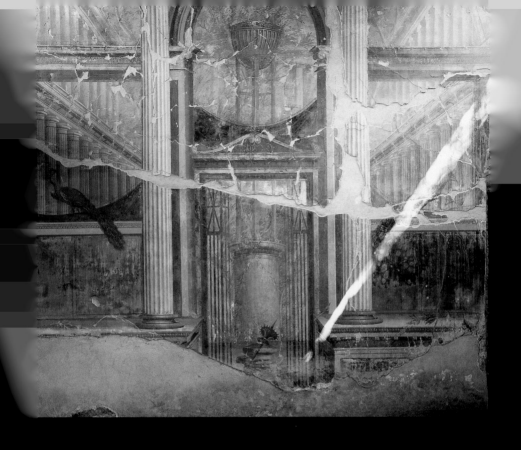

Wall-paintings from an ancient Roman Villa (above) that belonged to the family of Poppaea, wife of the emperor Nero, pro-
vided artist Garth Benton with the models for some of the paintings of the Outer Peristyle colonnade (right). Throughout the
Getty Villa, Benton cleverly combined elements from numerous ancient paintings, so that, while his walls are true in spirit to

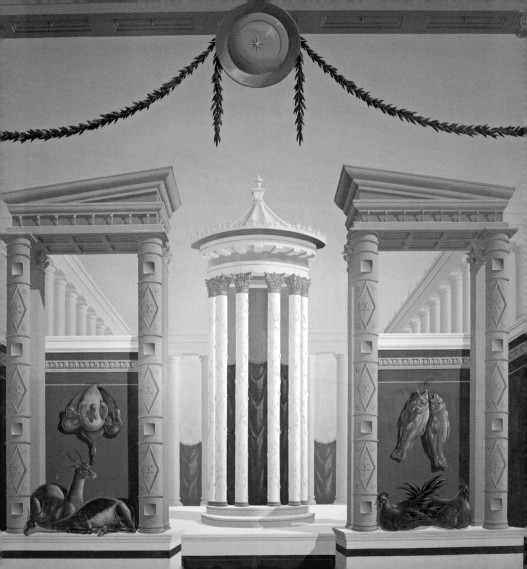

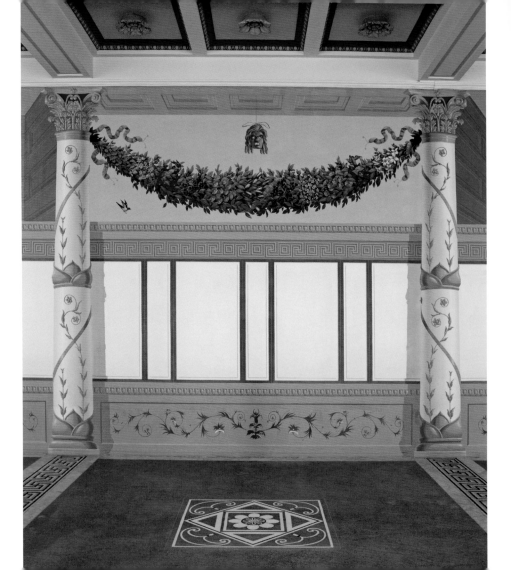

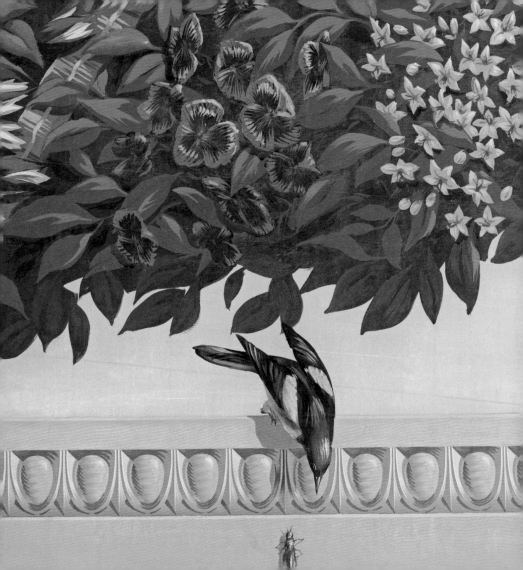

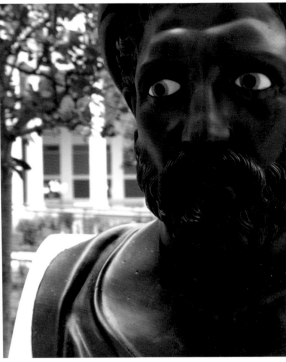

The bronze statuary in the outdoor gardens of the Getty Villa are modern replicas of ancient figures excavated at the Villa dei Papiri in Herculaneum in the eighteenth century. The originals are now housed in the National Archaeological Museum in Naples. Depicting athletes, statesmen, philosophers, mythological figures, and animals, they inhabit the garden, offering modern visitors both whimsy and food for thought.

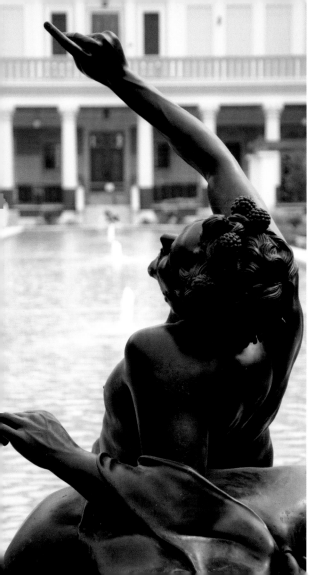
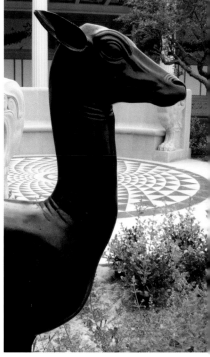

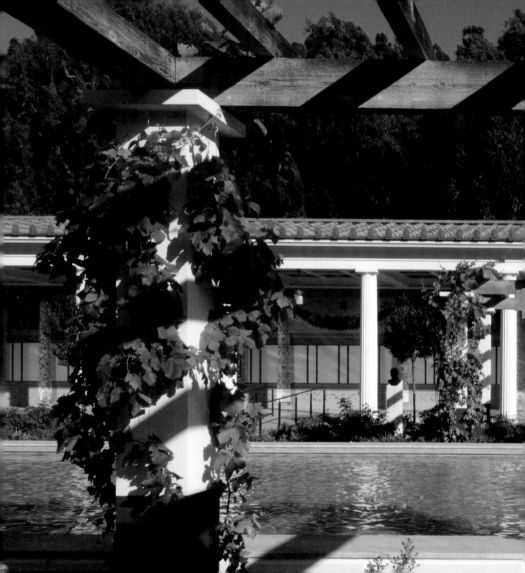

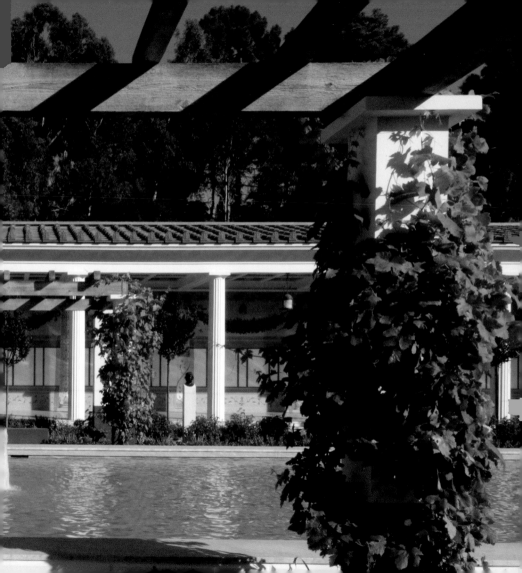

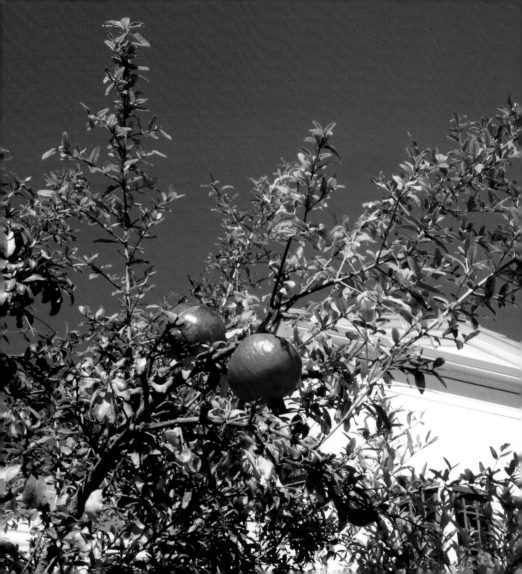

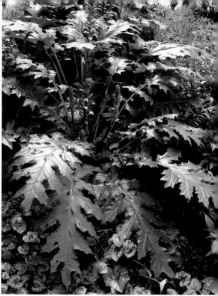

The plants and trees in the Villa's gardens are all known to have been cultivated by the ancient Romans. Both pomegranates and acanthus plants (seen in these two pictures) figured prominently in ancient myth, art, and architecture.

Although the Villa's gardens today are chiefly a source of pleasure, gardens in antiquity were an essential supply of fruit, vegetables, and herbs and yielded ingredients for perfumes, medicine, and even magic practices.

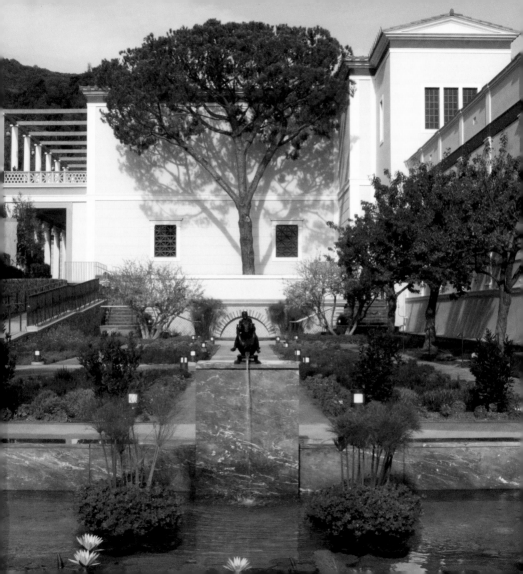

All photographs by Richard Ross except for title and copyright pages and pages 12, 13, 29 (top), 33 (left), 37, 38, and 47 by Ellen M. Rosenbery; pages 3, 15, and 26 by Tahnee L. Cracchiola; left cover flap and pages 16–17, 22, and 53–55 by Gerard Vuilleumier; right cover flap and pages 20–21, and 40–41 by Ellen M. Rosenbery and Gerard Vuilleumier; and page 14 courtesy of Art Resource/Scala.
Richard Ross photos are © Richard Ross with courtesy of the J. Paul Getty Trust.

Getty Publications
1200 Getty Center Drive, Suite 500
Los Angeles, CA. 90049-1682
www.gettypublications.org

Text by Kenneth Lapatin
Design by Kurt Hauser
Production by ReBecca Bogner
Printed by Tien Wah Press

Library of Congress Control Number: 2005932322
ISBN: 978-0-89236-833-4